Skira**M**ini**ART**books

D1019367

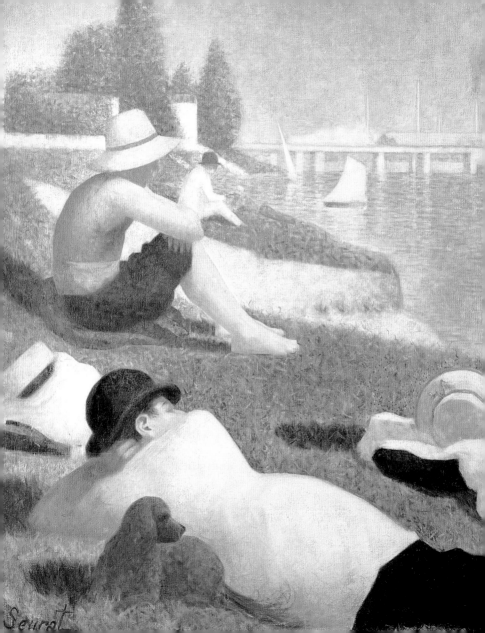

Seurat

Flaminio Gualdoni

POST-IMPRESSIONISM

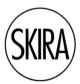

front cover
Georges Seurat
A Sunday on La Grande Jatte
(detail), 1884-86
Oil on canvas, 207 x 308 cm
The Art Institute, Chicago

Skira editore
SkiraMiniARTbooks

Editor
Eileen Romano

Design
Marcello Francone

Editorial Coordination
Giovanna Rocchi

Layout
Anna Cattaneo

Iconographical Research
Alice Spadacini

Editing
Maria Conconi

Translation
Robert Burns for Language
Consulting Congressi, Milan

First published in Italy in 2008
by Skira Editore S.p.A.
Palazzo Casati Stampa
via Torino 61
20123 Milano
Italy

www.skira.net

Printed and bound in Italy.
First edition

ISBN 978-88-6130-675-2

Distributed in North America by
Rizzoli International Publications,
Inc., 300 Park Avenue South,
New York, NY 10010.
Distributed elsewhere in the world
by Thames and Hudson Ltd.,
181a High Holborn, London
WC1V 7QX, United Kingdom.

facing title page
Georges Seurat
Bathers at Asnières
(detail), 1883-84
Oil on canvas, 200 x 300 cm
The National Gallery, London

© Foto Archivio Scala,
Firenze, 2008
© The Bridgeman Art Library
/ Archivi Alinari, Firenze
© Photo RMN, Paris – Hervé
Lewandowski – Réunion des
Musées Nationaux / distr. Alinari
© Succession H. Matisse,
by SIAE 2008
© Giacomo Balla, Pierre Bonnard,
Maurice Denis, Joaquín Sorolla
y Bastida, Édouard Vuillard,
by SIAE 2008
© Edward Steichen
Archivio Skira

Works owned by the
Soprintendenza are published
by permission of the Ministero
per i Beni e le Attività Culturali

The publisher is at the disposal
of the entitled parties as regards
all unidentified iconographic
and literary sources.

Index

Post-Impressionism

On May 3, 1888, Vincent van Gogh wrote to his brother Theo, who was involved in the Parisian art market, about his ideas on the painter of the future. This painter would have to be a colourist unlike any who had ever existed. He said that Manet had laid the groundwork, but the Impressionists had already used colours that were much more vivid than his. He continued, "I can't imagine the painter of the future living in small restaurants, setting to work with a lot of false teeth, and going to the Zouaves' brothels as I do. But I'm sure I'm right to think that will come in a later generation, and it is up to us to do all we can to encourage it, without question or complaint."

It is usually said that the term "Post-Impressionism" was coined by the art scholar Roger Fry in 1910 on the occasion of the *Manet and the Post-Impressionists* exhibition at London's Grafton Galleries. This is true. But the impulse to move beyond Impressionism was already crystal clear in Van Gogh's words twelve years earlier, at a time when he was not yet sure of his talents but not lacking a clear orientation. And it was generally clear to the entire generation of artists coming of age in Paris in the shadow of the Impressionist revolution.

It was a composite generation operating within the anti-academic viewpoints emerging from Impressionism. It encompassed orientations that differed greatly, but that were often closely intertwined. The main site of this meshing was the Salon des Artistes Indépendants, which opened its doors on December 1, 1884 at the Polychrome Pavilion, just a stone's throw from the Palais de l'Industrie. Like the 1863 Salon des Refusés, which had witnessed the scandal of Manet's *Déjeuner sur l'herbe*, the exhibitors at the Indépendants were strongly opposed to the selective, jury-mediated admissions process to the official Salon, the pre-eminent public exhibition in Paris. They favoured

a free exchange of artistic expression in which the artists themselves, and not some institution, are in charge. The founders included, among others, Albert Dubois-Pillet, Odilon Redon, Georges Seurat and Paul Signac, who also exhibited their works at the event.

When the exhibition opened, Seurat had already been working for several months on his masterpiece *Un dimanche après-midi à l'Île de la Grande Jatte* (*A Sunday on La Grande Jatte*). Seurat admired the noble and composed painting style of Pierre Puvis de Chavannes, but sought to reconstruct Classical perfection, which he saw as the model to be pursued, but on a new, scientific basis. Seurat was fascinated with the optical theories of Eugène Chevreul, author of the 1939 work *De la loi du contraste simultané des couleurs* (*The Principles of Harmony and Contrast of Colours*) in which Chevreul demonstrated that when colour A is juxtaposed with colour B, the latter changes its appearance by the seeming addition of the complement of colour A. If colours A and B are complementary, they tend to cause the other to appear lighter, otherwise, impure tones are generated. Chevreul later wrote prophetically in his 1864 essay *De l'abstraction considérée relativement aux Beaux-Arts* (*Abstraction considered in its relationship to the Fine Arts*) that the fine arts offer us only abstractions, even when they present us with a work that apparently reproduces a concrete image.

Pierre Puvis de Chavannes
Young Girls at the Seaside, 1879
Oil on canvas, 205 × 154 cm
Musée d'Orsay, Paris

Seurat began to construct his scenes of life simplifying his figures into static geometric solids with clear edges defined by a change in colour. He applied his paint in small, tightly spaced dots in a technique termed at the time "Pointillisme". In 1886, on the occasion of the public unveiling of the painting, the art critic Félix Fénéon would refer to

"… I can't imagine the painter of the future living in small restaurants, setting to work with a lot of false teeth, and going to the Zouaves' brothels as I do. But I'm sure I'm right to think that will come in a later generation, and it is up to us to do all we can to encourage it, without question or complaint."

Vincent van Gogh

the technique as "Neo-Impressionism", choosing that term over "Divisionism". The latter term however was preferred by Seurat and immediately adopted by Italian admirers of the Frenchman's work such as Segantini, Previati, Pellizza da Volpedo and Morbelli. "We have, therefore," wrote Fénéon, "not a mixture of material colours (pigments), but a mixture of differently coloured rays of light."

Accompanying and carrying on Seurat's new venture—Seurat died at the age of 31 in 1891—we have Armand Guillaumin and his teacher Camille Pissarro, a great impressionist who was swayed by the ideas of his younger colleagues. More importantly, however, we have Paul Signac, who continued the development of the theory with a stronger conception of the relations between colours and greater attention to the proportion of the coloured dots in relation to the dimensions of the overall composition.

It would be Signac, in his essay *D'Eugène Delacroix au Néo-Impressionnisme* (*From Eugène Delacroix to Neo-Impressionism*), published in 1899, to sum up the rules of the movement: "The Neo-Impressionist does not *stipple*, he *divides*. And dividing involves (…) guaranteeing all benefits of light, coloration and harmony by: i. An optical mixture of pigments which are pure (all the tints of the prism and all their tones); ii. The separation of different elements (locally applied colour, lighting colours, their reactions, etc.); iii. The balance of these elements and their proportion (following laws of contrast, deterioration, and irradiation); iv. Choosing a touch that is proportionate to the size of the painting." He explains that the separated brush-touch is only one of an infinitude of coloured elements which together compose the painting. It is an element that has the same importance as a note in a symphony. Sad or joyful sensations, calm or active effects are not achieved via the virtu-

osity of the brush work, but through the combination of tints, tones and lines. Many of these principles will form the basis of the Fauve paintings of Henri Matisse, André Derain and Georges Braque, and contribute to the initial abstractionist intuitions of Wassily Kandinsky.

Alongside the Seurats and Signacs, the "Indépendants" exhibition of 1884 included works by Redon, leader of another important current, Symbolism. Initially a movement that was prevalently literary, Symbolism was brought to the public's attention that same year by Verlaine's piece on the "accursed poets" Mallarmé, Corbière and Rimbaud. Two years later, when Rimbaud's *Illuminations* was published, Jean Moréas would sum it up perfectly as "dressing the Idea in a sensible form".

Verlaine explained that the poetry lay in the creating. What is necessary is to identify states of absolute purity in the human soul that can be distilled down to the very essence of humanity. The symbol is here, creation is here, and the term poetry here means something. In sum, he claims, poetry is the only possible human creation.

Redon and the more mature Gustave Moreau and Pierre Puvis de Chavannes were the spearheads in France of an attitude that would soon spread abroad, especially into the German-speaking areas, where it was expressed by authors such as Ferdinand Hodler, Arnold Böcklin, Fernand Khnopff and especially Gustav Klimt. In Vienna in 1897, Klimt, together with Joseph Olbrich and Koloman Moser, would found the Viennese Secession and the magazine *Ver Sacrum*. He would also be the teacher of Egon Schiele.

While the art of the Viennese Secession is characterised by its strong allegorical images and the use of gold to indicate a metaphysical world, along the lines of the

Byzantine tradition, the trend toward adopting esoteric and inspired attitudes in painting was manifested in France with Les Nabis, who developed the primary Symbolist attitude.

"Nabis" is a term deriving from the Hebrew for prophet, one whose expressions are mediated by the direct agency of divine inspiration. Restoring a sacred value to art and re-establishing painting based exclusively on the highest spiritual aspirations and a sense of truth that transcends all considerations of style or technique were the obscure aspirations that motivated artists like Van Gogh and Paul Gauguin, who met in Paris in 1887, and the Nabis group, who would coalesce three years later around Gauguin, Émile Bernard and Paul Sérusier in Pont-Aven in Brittany. Les Nabis would represent a veritable fraternity that included, among others, Édouard Vuillard, Pierre Bonnard, Maurice Denis, Ker-Xavier Roussel, Félix Vallotton and Paul-Élie Ranson.

It was within this group that the predilection ripened for emblematic subjects and hieratic, simplified painting in the manner of ancient Egypt and Rome, with strong, flat colours and pronounced, sinuous borders, which would progressively gain stature as a new pictorial style above and beyond its symbolic intent.

When the man of letters Georges-Albert Aurier published the definition of pictorial Symbolism in *Mercure de France*, he wrote that: "The work of art has to be first of all *ideist*, because its one aim will be the expression of an idea; secondly, symbolist, as it will express this idea with forms; thirdly, synthetic, as it will put down these signs and forms in a generally understandable manner; fourthly, subjective, because the object will never be considered merely as an object, but as the expression of an idea perceived by the subject; fifthly, decorative, because decorative painting, such as the Egyptians and also probably the Greeks and

Paul Signac

Opus 217. Against the Enamel of a Background Rhythmic with Beats and Angles, Tones, and Tints, Portrait of M. Félix Fénéon in 1890, 1890
Oil on canvas, 73.5 × 92.5 cm
The Museum of Modern Art, New York
Fractional gift of Mr. and Mrs. David Rockefeller

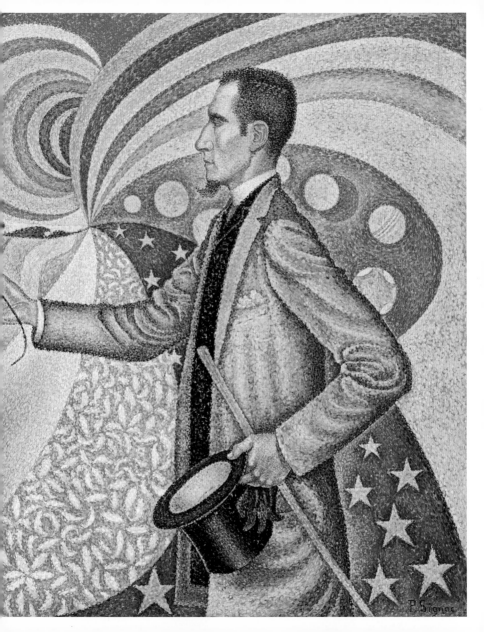

"Art for art's sake? Why not.
Art for life's sake? Why not.
Art for pleasure's sake? Why not.
What does it matter so long
as it is art."

Paul Gauguin

Primitives conceived it, is no other than a manifestation of art which is at one and the same time subjective, synthetic, symbolist and *ideist.*"

While artists still in the blush of youth such as Bonnard and Vuillard would not fully develop their personalities until years later and become models of a painting based on a poetic intimism accomplished through the mastery of light colours, at this time the two most complex personalities and greatest geniuses were Gauguin and Van Gogh.

Recently back from his first trip to Martinique, in late 1888 Gauguin worked for two months together with Van Gogh in Arles in the south of France. Vincent wrote to his brother Theo in January 1889: "Old Gauguin and I understand each other basically, and if we are a bit mad, what of it? Aren't we also thoroughly artists enough to contradict suspicions on that score by what we say with our brush? Perhaps someday everyone will have neurosis, St. Vitus's dance, or something else. But doesn't the antidote exist? In Delacroix, in Berlioz, and Wagner? And really, as for the artist's madness of all the rest of us, I do not say that I especially am not infected through and through, but I say and will maintain that our antidotes and consolations may, with a little good will, be considered ample compensation."

Above and beyond the perhaps overly fervid anecdotage accumulating around such an irregular figure as Vincent van Gogh, whose brief years were punctuated with episodes of mental derangement and ended with his suicide on July 29, 1890 in Auvers-sur-Oise, the painting styles of the two artists are actually quite different.

Van Gogh matured irregularly, pursuing a multitude of cues ranging from the use of pure colours to the decorative flat colours typical

of the Japanese woodcuts that were greatly in vogue in a Paris caught up in an Orientalist rage, and from his simple, almost genre iconography, which allowed him to concentrate into his painting all the emotional charge that a given situation aroused in him, to his use of fluid and intense brushwork, with his urgent onrush of pictorial gestures capable of deforming the normal mode of visual perception. His painting is irregular, deviating not only from an effete academism, but also from the new contemporary trends, which were increasingly oriented toward seeking justification in a solid intellectual and theoretical background.

It was this irregularity, combined with a brief and searing biography that reads like a romance novel, to exalt him to the ranks of legend immediately upon his death, to make him immediate fodder for mythmaking.

Maurice Denis
The Muses, 1893
Oil on canvas,
171.5 x 137.5 cm
Musée d'Orsay, Paris

Gauguin's is a completely different story. First of all, he did not fully grasp Van Gogh's spontaneous and anomalous innovativeness. Nurtured on Symbolist culture and, like Seurat, in competition with the noble forefather Puvis de Chavannes, Gauguin was always concerned with providing a conceptual basis for his work. Gauguin explained: "Puvis explains his idea, yes, but he does not paint it. He is a Greek while I am a savage, a wolf in the woods without a collar. Puvis would call a painting "Purity", and to explain it he would paint a young virgin holding a lily in her hand—a familiar symbol; consequently one understands it. Gauguin, for the title "Purity", would paint a landscape with limpid waters; no stain of the civilized human being, perhaps a figure. Without entering into details there is a wide world between Puvis and myself. As a painter Puvis is a lettered man but he is not a man of letters, while I am not a lettered man but perhaps a man of letters."

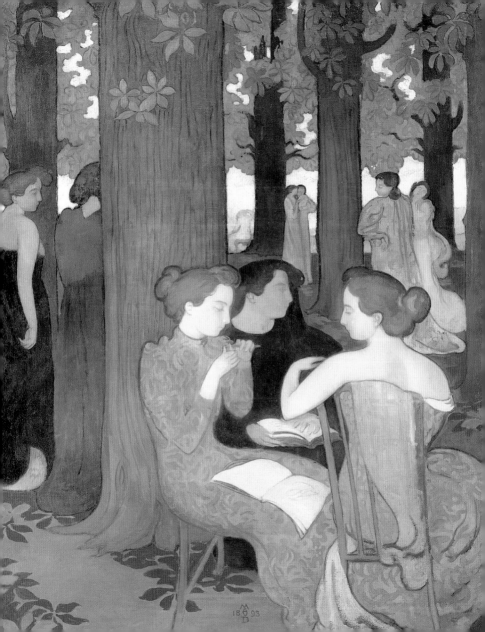

And again, in his brief *Notes* of 1884-85: "Painting is the most beautiful of all arts. In it, all sensations are condensed; contemplating it, everyone can create a story at the will of his imagination and—with a single glance—have his soul invaded by the most profound recollections; no effort of memory, everything is summed up in one instant. A complete art which sums up all the others and completes them. Like music, it acts on the soul through the intermediary of the senses: harmonious colours correspond to the harmonies of sounds. But in painting a unity is obtained which is not possible in music (…)".

In 1891, the year after Van Gogh's suicide, Gauguin embarked for Tahiti, later going to the village of Atuona on the southern coast of Hiva Oa, in the Marquesas Islands, where he would spend the rest of his life. He believed it was necessary to return to a condition of primitive purity in order to develop a newly sacred style of painting free of the filters that European culture lays over the original truth. His synthetic style is animated by strong, warm tones, and the hieraticity that Les Nabis sought in Egypt or Byzantium was replaced by that of the indigenous statuary that was to became one of his favourite subjects. His book *Noa-Noa*, published in 1897 in the *Revue Blanche*, the cultural bible of the times, was a sensation.

While Gauguin needed to escape "civilisation" on his quest for original purity, a master from the early generation of Impressionists such as Paul Cézanne preferred the total isolation of his native land, Provence. Cézanne's position with respect to Impressionism was problematic right from the start. While he too believed in the importance of working *en plein air* and in the primacy of visual perception over academic rules of composition and contrived light-

ing, he was immediately convinced that this experience could only be a transition toward an ulterior synthesis, in which the inner geometries and physical sensation of nature become one and the same; he wanted to make Impressionism into something solid and durable.

"Everything we see falls apart, vanishes. Nature is always the same, but nothing in her that appears to us, lasts. Our art must render the thrill of her permanence along with her elements, the appearance of all her changes. It must give us the taste of her eternity", wrote Cézanne. The thrill of duration united with the solidity of the form underlying the appearance is what allows painting to transcend sensation in favour of a classical measure. And instead of being imposed by the artist upon our vision as it was in the past, this measure is brought to the surface by the artist who analyses what is seen, it being the germ of truth that reality contains within itself.

"Couture used to say to his pupils: 'keep good company, that is: go to the Louvre. But after having seen the great masters who repose there, we must hasten out and by contact with nature revive within ourselves the instincts, the artistic sensations which live in us'". Cézanne once again, here signifying that painting outdoors and working on the motif are not in contradiction with tradition, but serve to help us recognise in the fullness of our lives that which only the intellect had previously grasped. In the years 1882-90, when he chose as his favourite subject Mount Sainte Victoire—to which he would return in the final years of his life, after the turn of the twentieth century—he began a process of meticulous simplification, sharpening the visual elements into essential colour zones, purifying the image of all accessory detail, and adopting a sober, raw colour as a sort of building block for the essence, the solid and permanent essence, of the image.

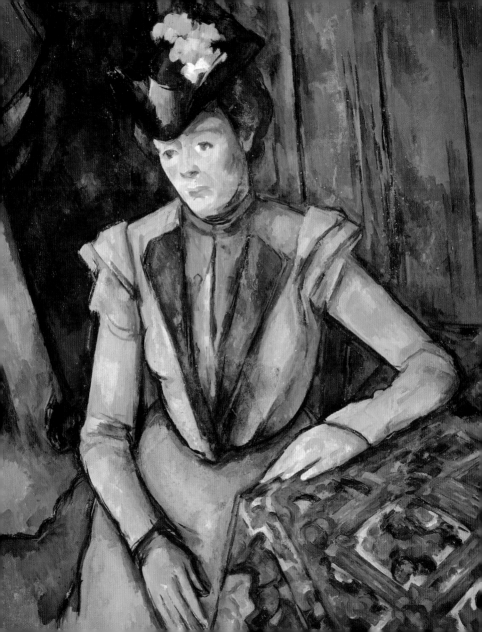

Isolated from everyone, Cézanne was also absent during the large Parisian exhibition of his works staged by the noted art merchant Vollard. The exhibition nevertheless succeeded in influencing the new generation because it confirmed that a synthetic simplification of the image is one of the main approaches to adopt. It was held in 1895, the same year that the art merchant Samuel Bing founded the gallery L'Art Nouveau – La Maison Bing, a place not only for the dissemination of the established fashion of *japonisme*, but also for the affirmation of great masters and the incubation of the young international generation. Exhibitors included Edvard Munch, Auguste Rodin, Henri de Toulouse-Lautrec, Camille Claudel, Fernand Khnopff, Constantin Meunier, Félix Vallotton, Henri van de Velde, Théo van Rysselberghe and Édouard Vuillard.

Paul Cézanne
Woman in Blue, circa 1904
Oil on canvas, 88.5 x 72 cm
The State Hermitage
Museum, St. Petersburg

At that time, Rodin, an artist who was prying sculpture away from the bonds of academic rhetoric, was involved in two extraordinary projects. In 1895 *The Burghers of Calais* was inaugurated in memory of the six burghers who were willing to sacrifice themselves to save their city. However, Rodin was not satisfied. He wanted to place his statues, he wrote, one behind another, in front of the town hall, right in the paved part of the square as a sort of living procession of suffering and sacrifice. The inhabitants of Calais would have almost brushed against them in passing and strongly felt the ancient solidarity binding them to these heroes. Rodin felt that this would have brought out the full power of his work. However, the authorities rejected this plan and forced him to place his statues on a pedestal that was both inappropriate and ugly: a great mistake in the artist's eye. Other disappointments lay in store regarding the monument to Honoré de

Balzac that Émile Zola commissioned him to do for the Société des Gens de Lettres. Much loved by Medardo Rosso, who was in Paris right at that time and found some time to spend with his colleague, and also by intellectuals such as Monet, Debussy, Signac and Clemenceau, the sculpture was attacked by those who felt that a monument must be celebratory and saw Rodin's as merely a rough rendition. It was not until 1939 that it was finally given a public location. Rodin sought to create sculpture that was intimately classical and as energetic and potent as ancient sculpture, a reinvention and not an imitation. After this momentary setback he would go on to be considered in the twentieth century the father of modern sculpture.

Among the artists hosted by Bing there was also the American Louis Comfort Tiffany, founder of a factory that produced coloured glass using historical techniques in line with the ideals predicated by the Arts & Crafts movement of William Morris. Tiffany was a pioneer of that which would be dubbed, by none other than the Bing gallery, Art Nouveau. At the 1895 Salon, Tiffany exhibited stained glass windows based on cartoons by Vuillard, Bonnard, Lautrec, Sérusier and Vallotton.

Vincent van Gogh
Self-portrait
(detail), 1889
Oil on canvas, 65 x 54.5 cm
Musée d'Orsay, Paris

Henri de Toulouse-Lautrec gained success in 1891 as an *affichiste*, creating a poster for the Moulin Rouge, a famous nightspot that opened its doors in 1889. He later specialised in theatre bills and colour lithographs, a widely used technique since it was associated with the burgeoning market for cultural magazines. A prolific painter and graphic artist, he created a strong synthetic style, as well as an iconography dominated by the *demi-monde* that gravi-

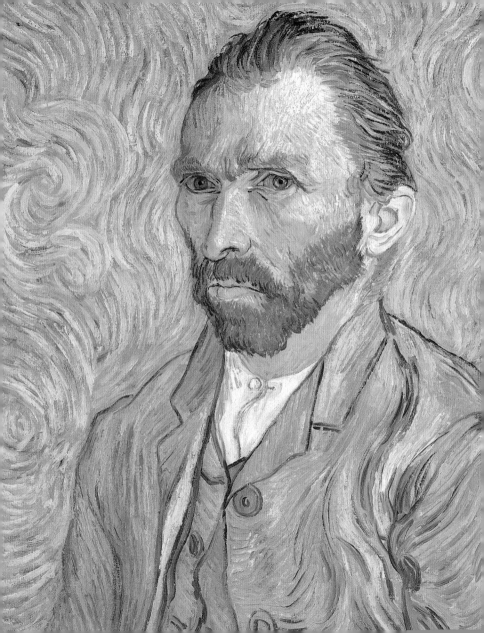

tated around the stage, the *café-concert* and the circus. These are the themes, along with the abrupt, lively colours of Toulouse-Lautrec's painting, that would influence the young Pablo Picasso. After having debuted at the Els 4 Gats cabaret in Barcelona, in 1900 Picasso took his first trip to Paris, setting up shop in the Montmartre district, where he would settle in 1904.

Max Jacob, Guillaume Apollinaire, André Salmon, Pierre Mac Orlan, Francis Carco and Roland Dorgelès are the young emerging intellectuals in the Montmartre circles, which orbited around several symbolic locations. Nightspots such as the Moulin Rouge, Le Chat Noir and Le Divan Japonais—where Yvette Guilbert debuted and was eternalised by Toulouse-Lautrec and also by Rosso—but especially Le Lapin Agile, all became, in a perfectly bohemian climate, the stomping grounds of writers and artists such as Picasso and his fellow countrymen Juan Gris and Julio González, as well as Maurice Utrillo, Théodore Steinlen and Amedeo Modigliani. The Bateau-Lavoir was a bizarre building housing the studios of numerous artists. It was there in 1908, thanks to the initiative of Picasso, that a memorable soirée was held in honour of Henri Rousseau, nicknamed "Le Douanier" (the customs agent) because of his means of making a living. In spite of the fact that Rousseau had debuted in 1886 at the exhibition of the Indépendants, it was only thanks to the appreciation of his work by young artists like Picasso, Matisse, Derain and Delaunay—as well as by a writer no less irregular than he, Alfred Jarry, the author of *Ubu Roi* in 1894—that his style steeped in all its naïveté and exoticism, so wildly visionary as to make him a forerunner of the Surrealists, began to be seen as an authentic artistic position and not as mere uncultivated eccentricity.

26

Born in Livorno, Modigliani arrived in Paris in 1906 and became acquainted with Constantin Brancusi, in addition to the bohemia of Montmartre and then of Montparnasse. Brancusi arrived in Paris from Romania in 1904. Two years later he was noted by Rodin, Rosso, Maillol, Bourdelle and Despiau, and accepted into the Salon d'Automne, establishing in the meantime relations with the artistic colony of Montmartre. Brancusi worked within a primitive, essential idea of sculpture marked by extremely simplified forms in which the geometric interplay of the volumes and surfaces prevails over any idea of representation.

Modigliani would follow him along this primitivist path, at first trying his hand at sculpture and then dedicating himself to a painting style whose hieratic simplifications evoke a feeling of primitive art, from Pre-Colombian to ancient Egyptian art, balanced by a strong and spare colour scheme, even at the expense of colouristic harmony.

It would be Modigliani's painting that influenced many young artists arriving in Paris in the early 1910s from other countries: Chaïm Soutine, Michel Kikoine, Marc Chagall and Moïse Kisling.

In the meantime, other crucial events occurred. At the 1905 Salon d'Automne, Matisse, Vlaminck, Derain and Marquet earned the appellative *fauves*, or "ferocious beasts", for the disruptive force of their colours and the expressionist power of their works.

In his Bateau-Lavoir studio, Picasso worked long on a large format painting, finally unveiling it to his friends one evening in 1907. The innovativeness of the work was so great that even his closest cohorts were left dumbstruck. It was *Les Demoiselles d'Avignon*.

• Symbolism • Irregular painti
colours • Chromatic mix • Embl
of nature • Poetic intimism •
perfection • Divisionism • Colour
flow • Nabis • Spiritual aspirati
the image • Pointillism • Comple
• Geometrical solids •

g • Simultaneous contrast of
natic quality • Inner geometries
eo-Impressionism • Classical
tic effects • Fauves • Emotional
ns • Synthetic simplification of
nentary tone • Hieratic painting

Works

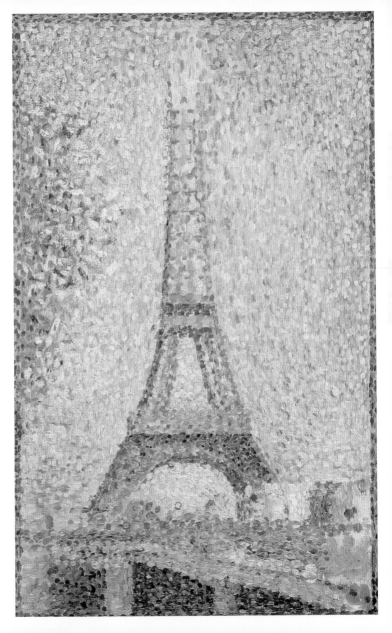

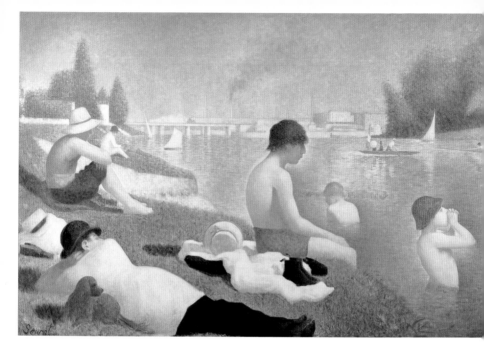

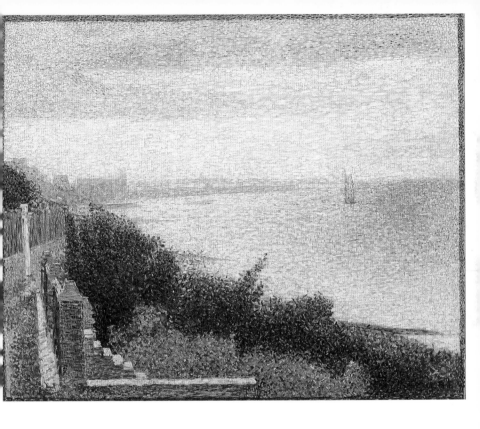

33

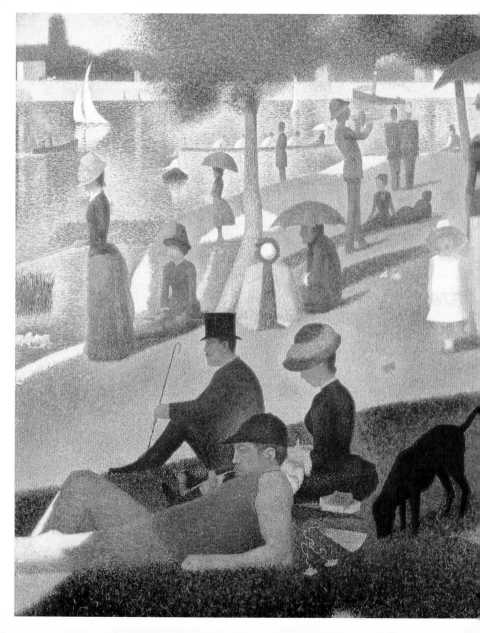

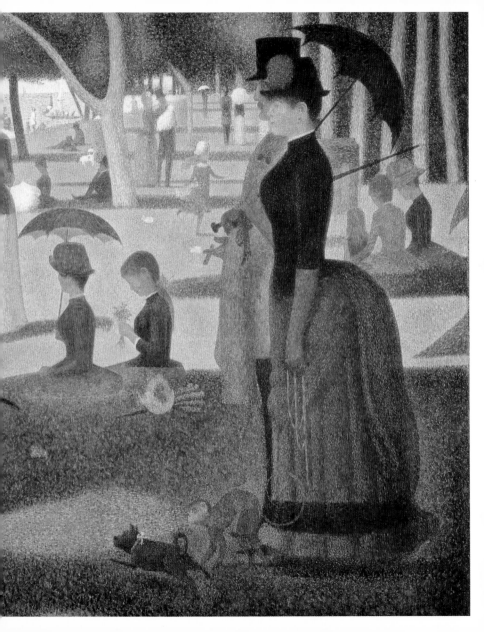

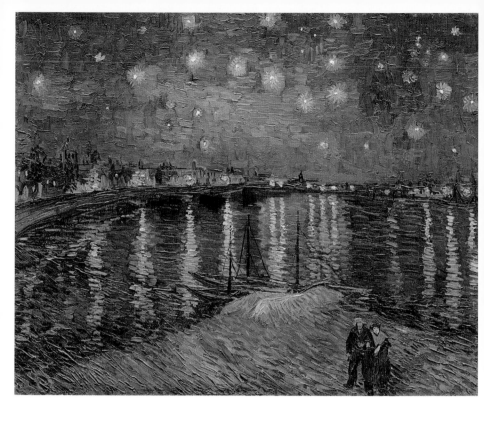

36

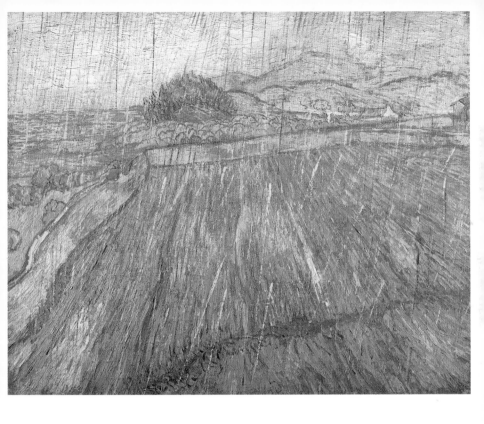

5. Vincent van Gogh
The Starry Night, 1888

6. Vincent van Gogh
Rain, 1889

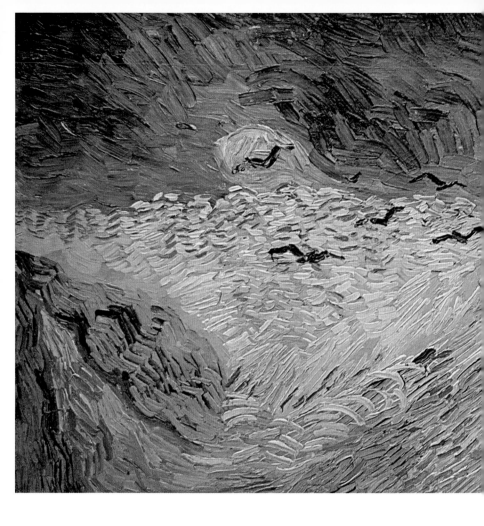

7. Vincent van Gogh
Wheatfield with Crows, 1890

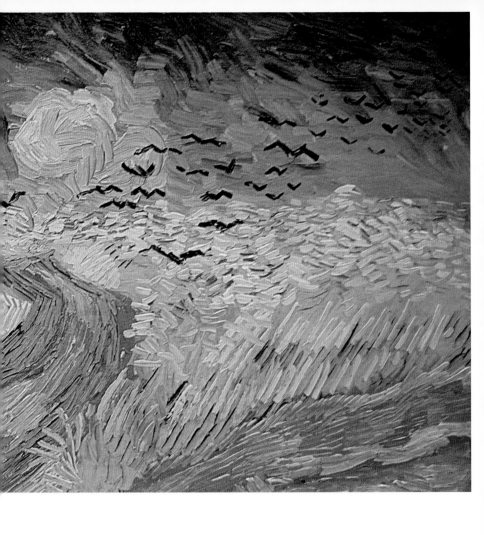

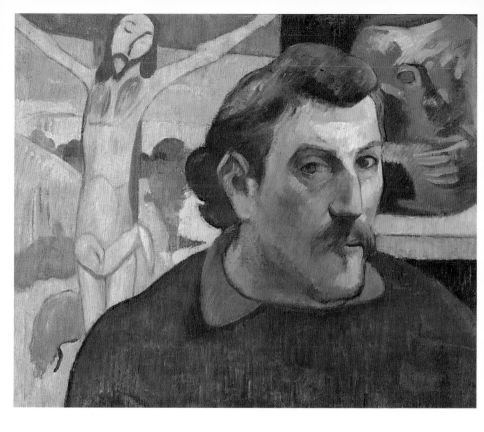

8. Paul Gauguin
Self-Portrait with Yellow Christ, 1890-91

9. Paul Gauguin
Self-Portrait with Palette, 1891

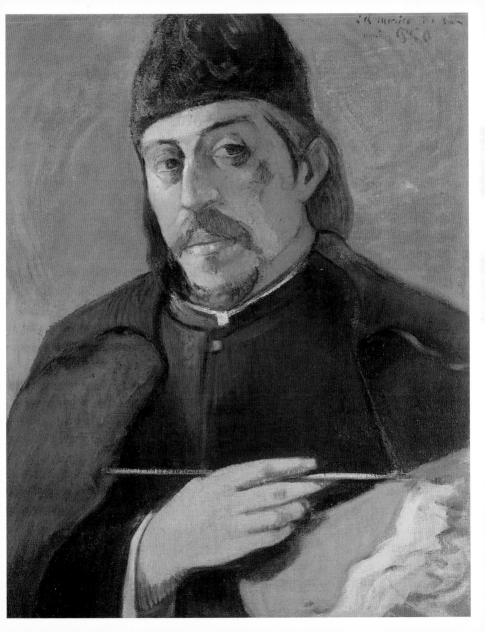

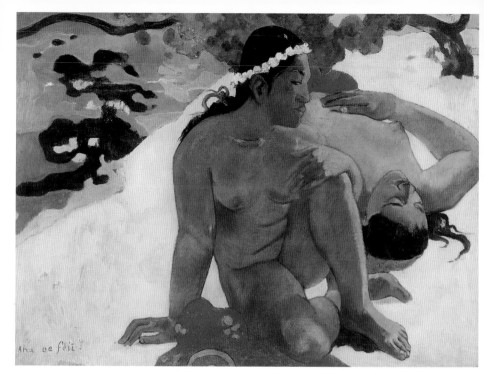

10. Paul Gauguin
Aha oe feii?
(What! Are you jealous?),
1892

11. Paul Gauguin
Still-Life with Fan,
1888-89

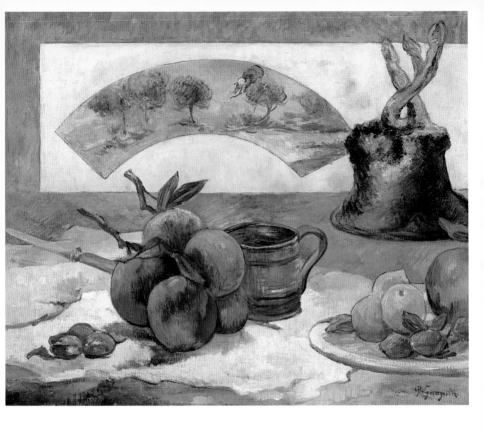

43

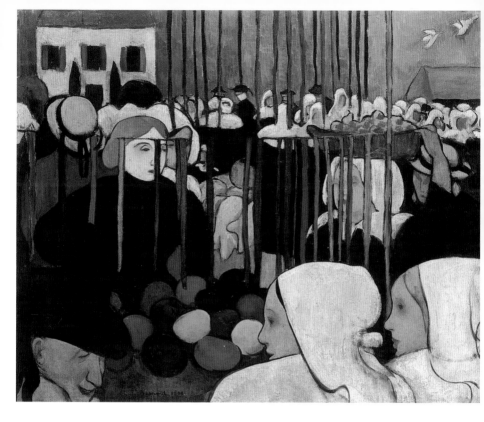

12. Émile Bernard
Marché à Pont-Aven (Market in Pont-Aven), 1888

13. Émile Bernard
Breton women picking apples, 1889

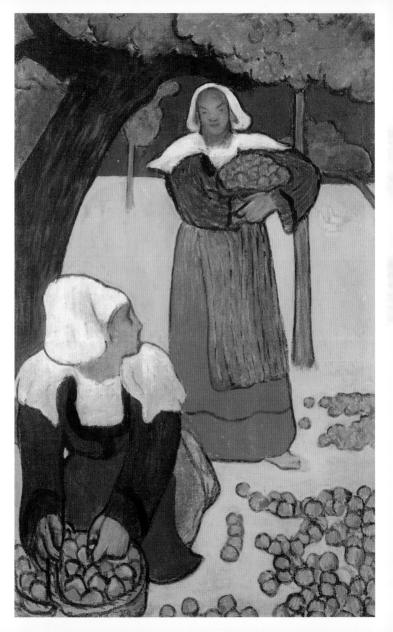

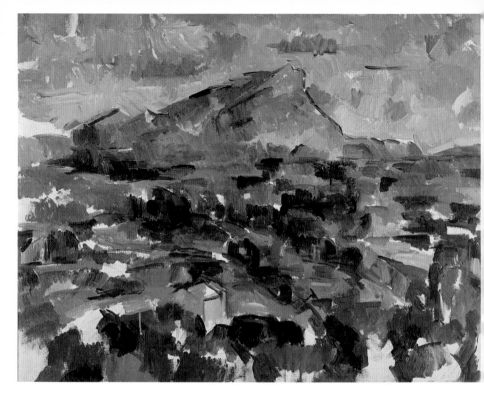

14. Paul Cézanne
Mount Sainte Victoire, 1905

15. Paul Cézanne
Mount Sainte Victoire, 1905

46

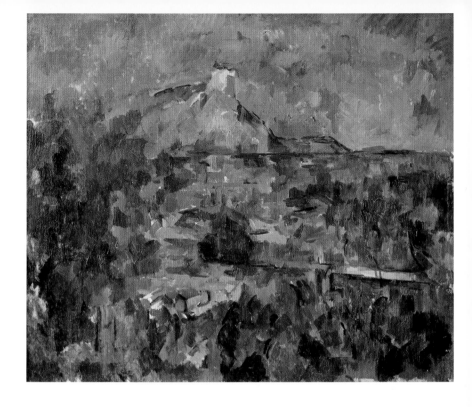

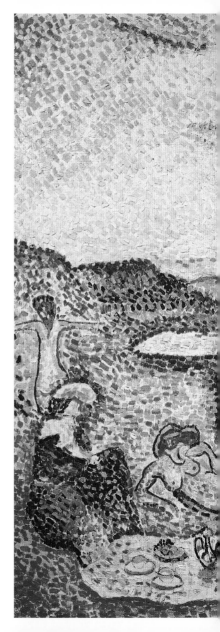

16. Henri Matisse
Luxe, Calme et Volupté,
1904-1905

48

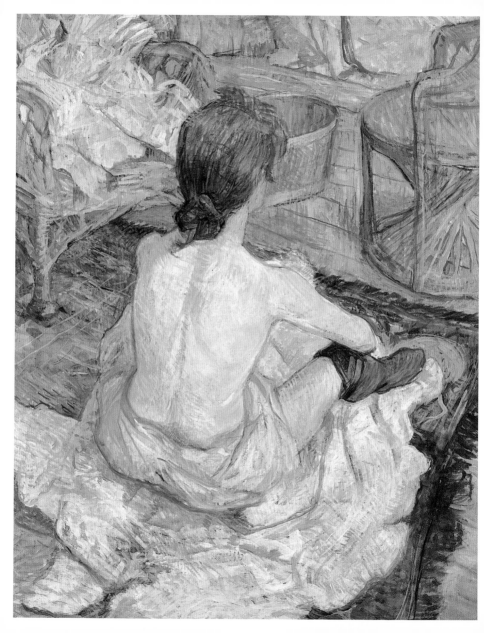

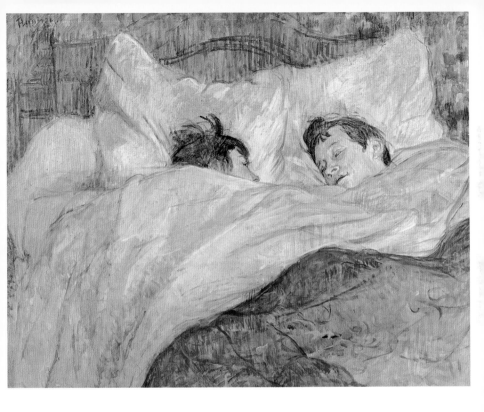

**17. Henri
de Toulouse-Lautrec**
La toilette, 1889

**18. Henri
de Toulouse-Lautrec**
The bed, circa 1892

Following pages
**19. Henri
de Toulouse-Lautrec**
*The Red-Haired Girl
in a White Blouse*, 1889

**20. Henri
de Toulouse-Lautrec**
Woman at the Window, 1893

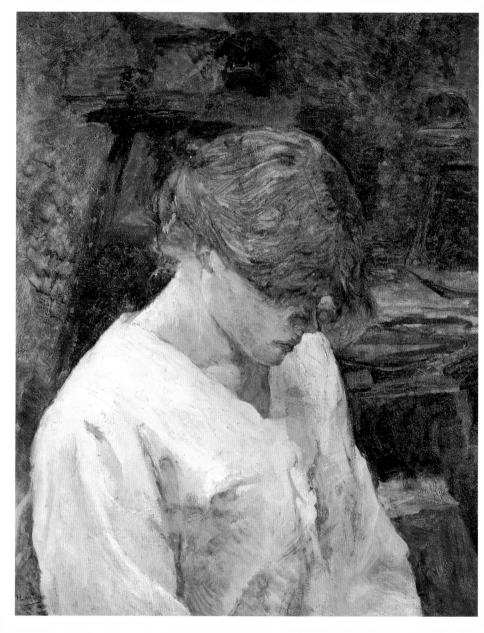

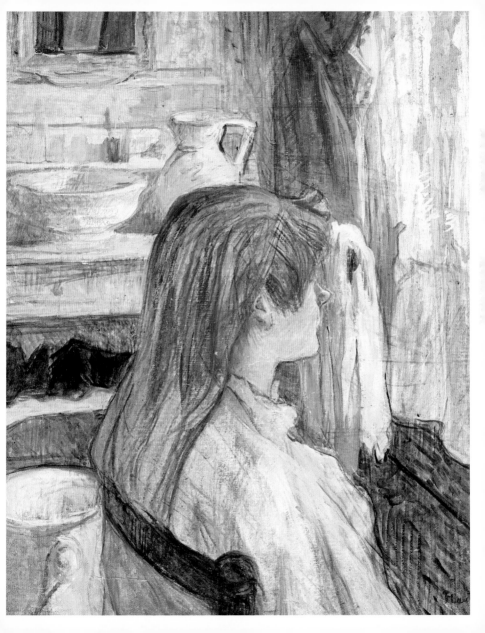

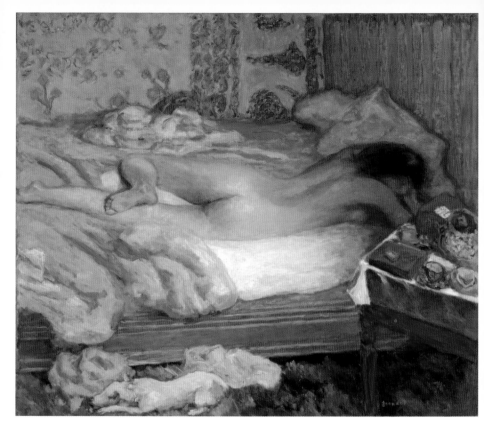

21. Pierre Bonnard
Siesta – The Artist's Studio,
1900

22. Pierre Bonnard
Nude in the tub, 1903

54

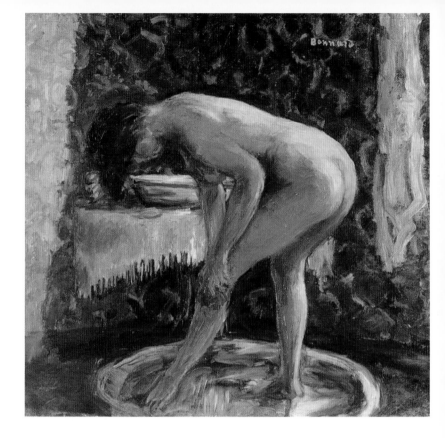

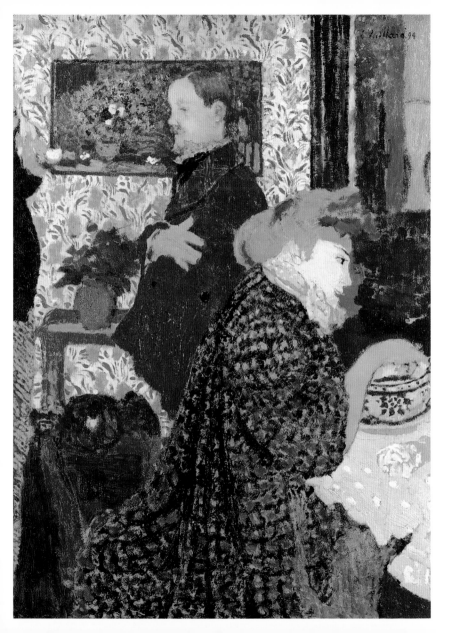

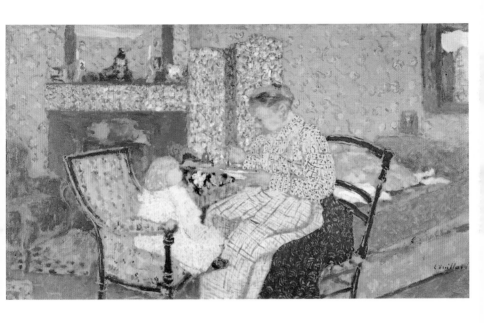

23. Édouard Vuillard
*Misia and Félix Vallotton
at Villeneuve,* 1899

24. Édouard Vuillard
La Soupe d'Annette, 1900

57

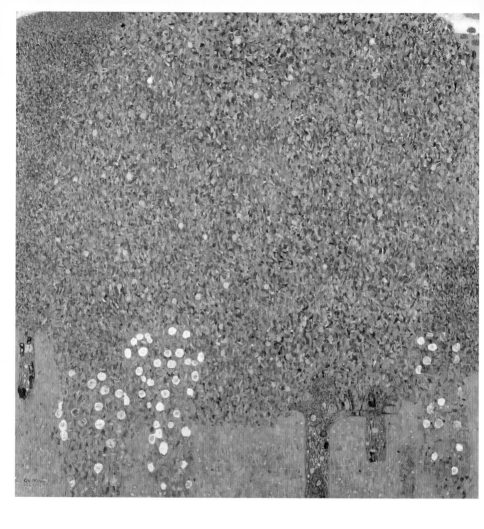

25. Gustav Klimt
Rosebushes under Trees,
circa 1905

26. Gustav Klimt
Avenue in Schloss Kammer
Park, 1912

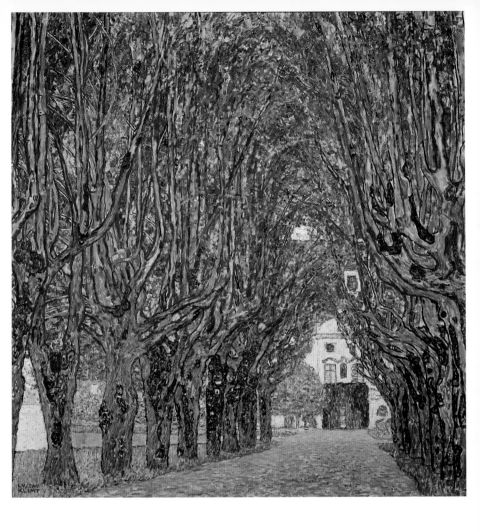

59

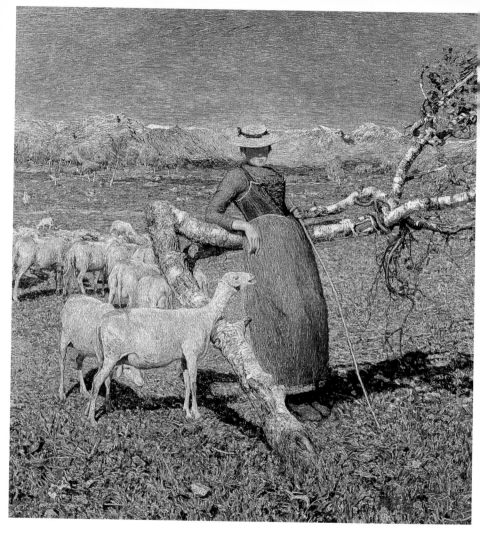

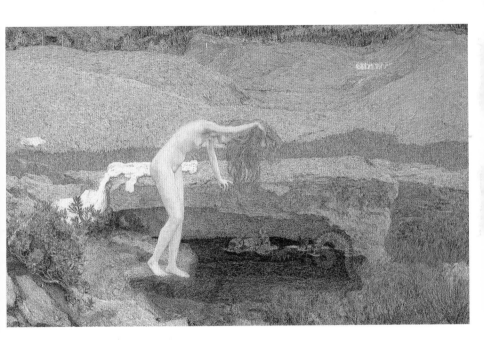

27. Giovanni Segantini
Highnoon in the Alps, 1892

28. Giovanni Segantini
Vanity (The source of evil),
1897

Following pages
29. Giacomo Balla
*Open-air portrait
(Leonilde Imperatori)*,
circa 1902-1903

30. Giacomo Balla
La pazza (The Madwoman),
1905

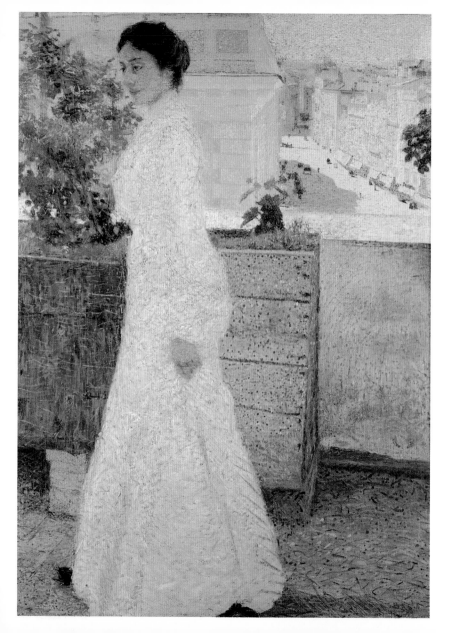

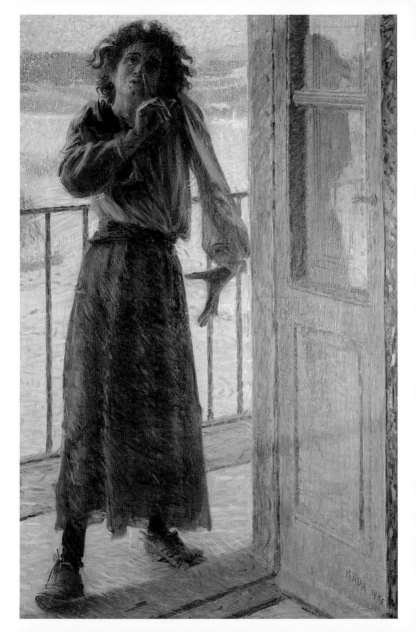

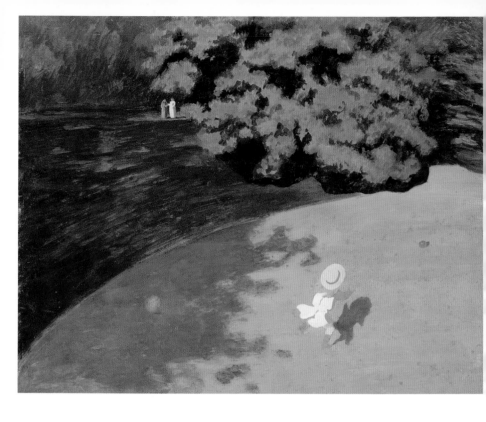

31. Félix Vallotton
*The Balloon (Corner of a Park
with a Child Playing)*, 1899

32. Giacomo Balla
The Fiancee in the Pincio,
1902

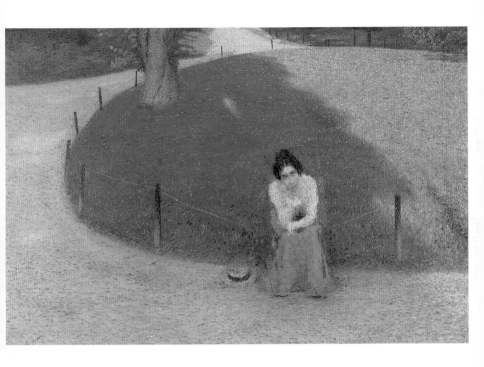

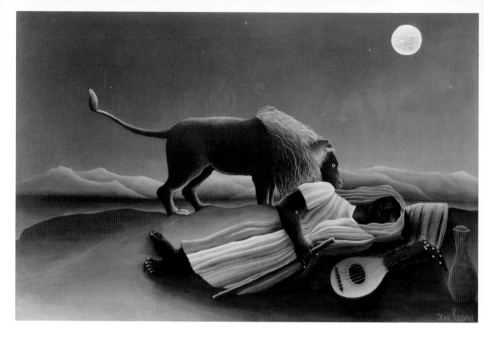

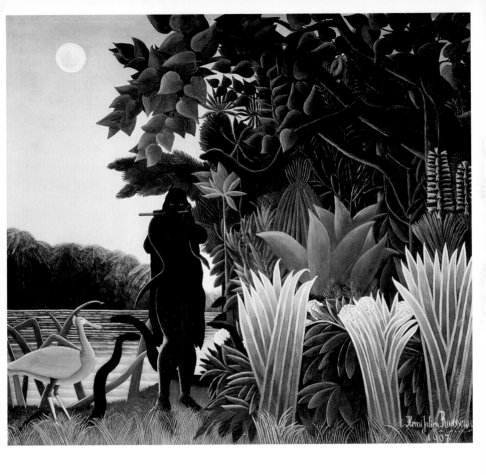

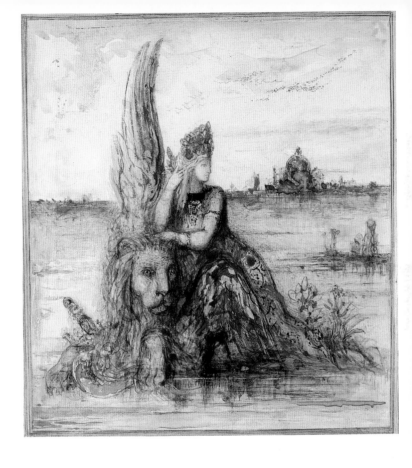

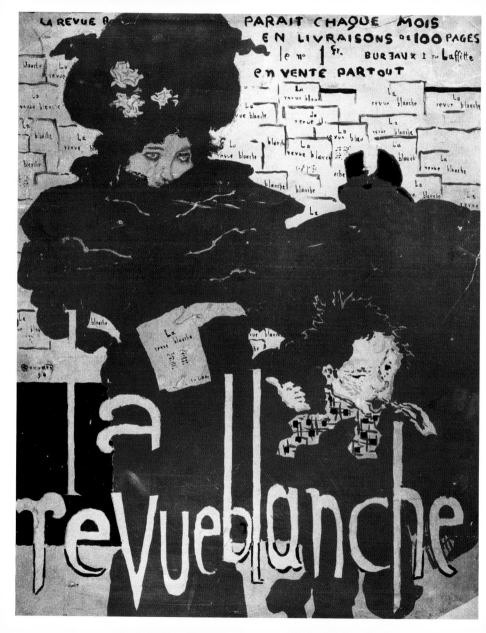

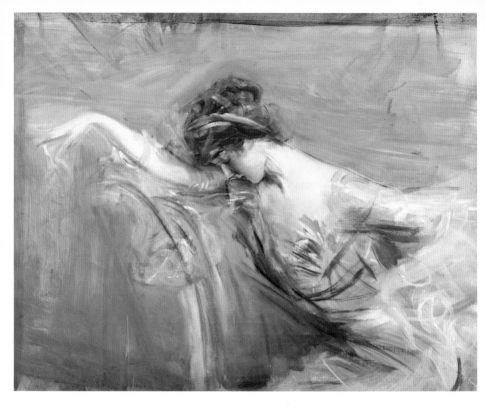

41. Giovanni Boldini
Mademoiselle Laure, 1910

42. Giovanni Boldini
The Young Subercaseaux, 1891

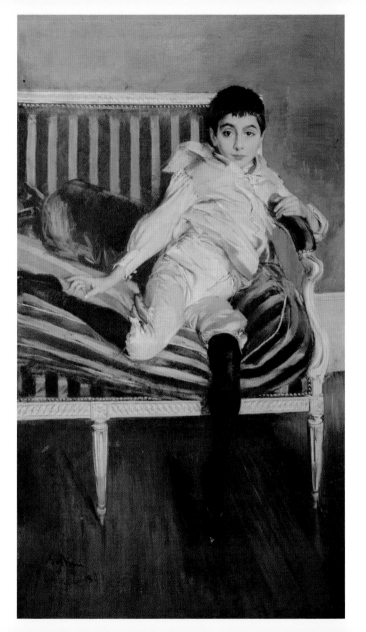

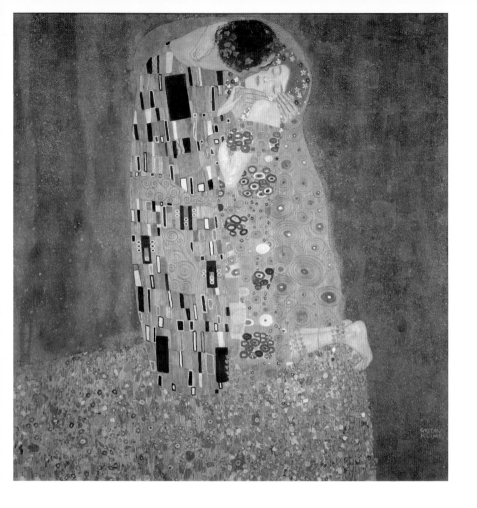

43. Gustav Klimt
The Kiss, 1907-08

44. Gustav Klimt
Portrait of Emilie Flöge, 1902

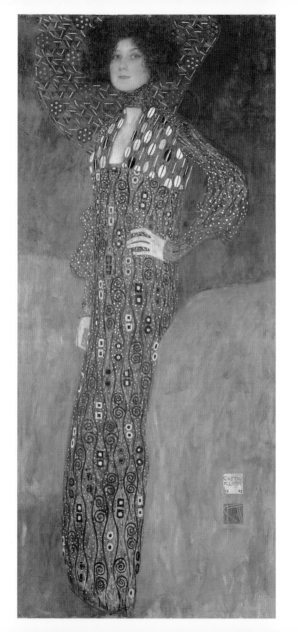

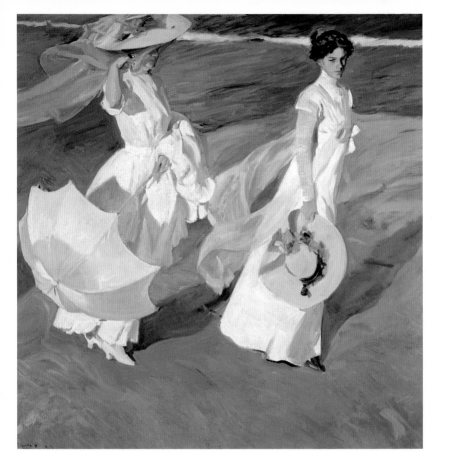

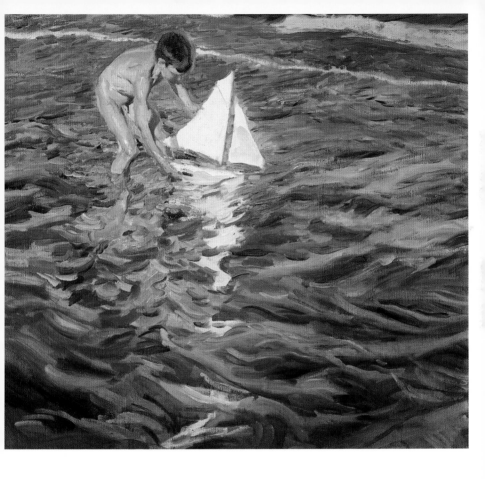

**45. Joaquín Sorolla
y Bastida**
Walk on the Beach, 1909

**46. Joaquín Sorolla
y Bastida**
The Young Yachtsman, 1909

Following pages
47. Amedeo Modigliani
Red Nude, 1917

79

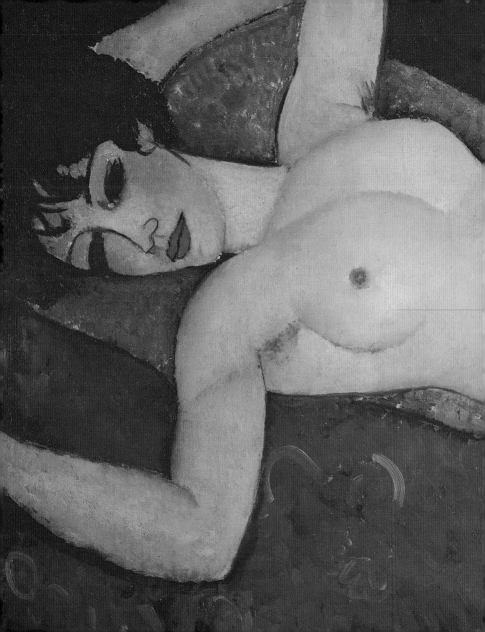

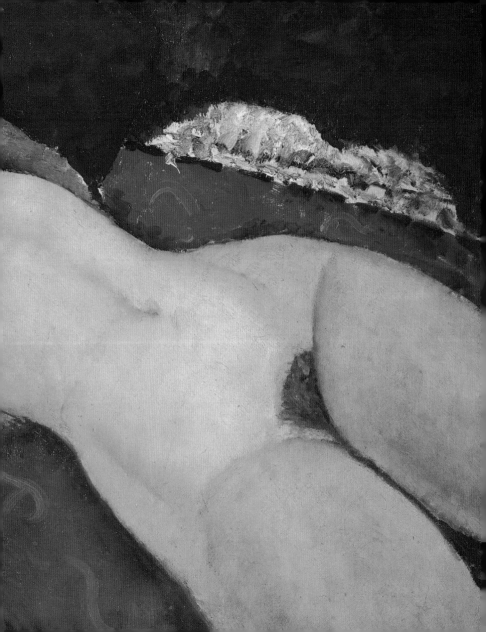

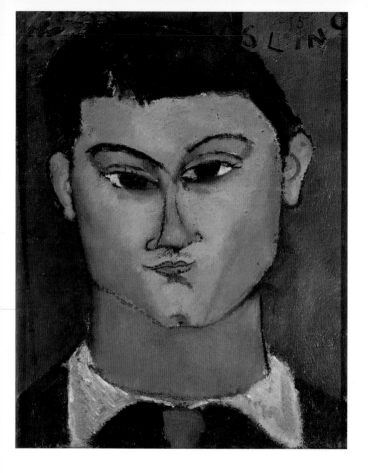

48. Amedeo Modigliani
Portrait of Moïse Kisling, 1915

49. Amedeo Modigliani
Paul Guillaume Seated, 1916

Following pages
50. Edward Steichen
Maurice Maeterlinck, 1906

51. Edward Steichen
Eleonora Duse, 1903

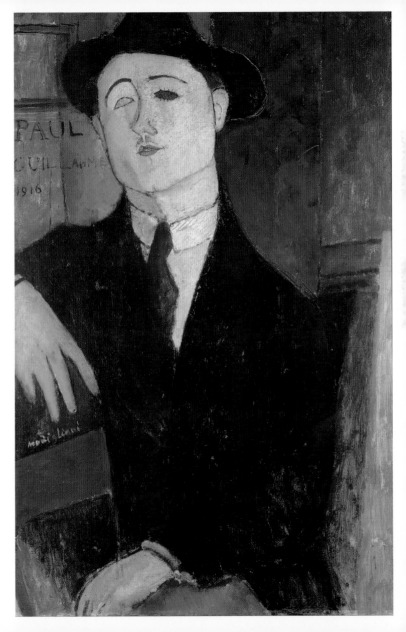

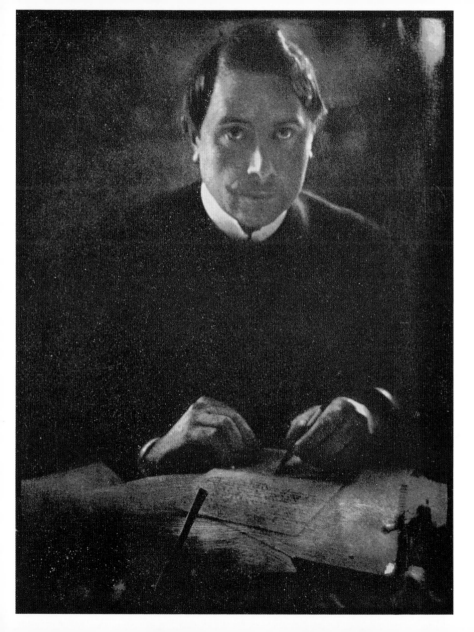

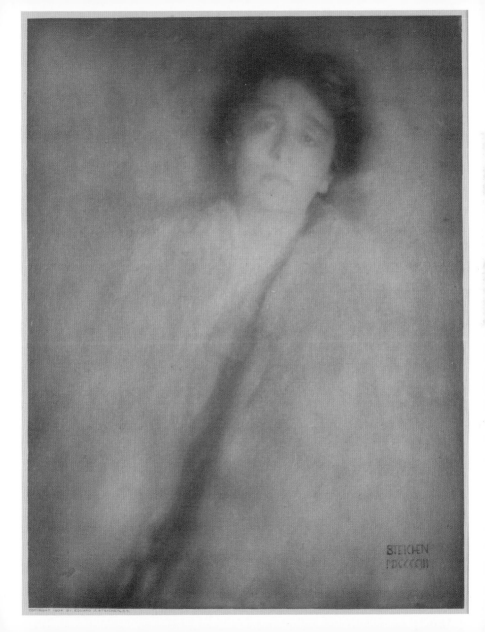

Appendix

Catalogue of the Works

1. Georges Seurat
La Tour Eiffel
(*Eiffel Tower*), 1889
Oil on canvas, 24.1 x 15.2 cm
Fine Arts Museums of San
Francisco, San Francisco

2. Georges Seurat
Une Baignade, Asnières
(*Bathers at Asnières*),
1883-84
Oil on canvas, 200 x 300 cm
The National Gallery, London

3. Georges Seurat
Grandcamp, Evening, 1885
Oil on canvas, 65 x 81.5 cm
The Museum of Modern Art,
New York

4. Georges Seurat
*Un dimanche après-midi
à l'Île de la Grande Jatte*
(*A Sunday on La Grande
Jatte*) 1884-86
Oil on canvas, 207 x 308 cm
The Art Institute, Chicago

5. Vincent van Gogh
The Starry Night, 1888
Oil on canvas, 72.5 x 92 cm
Musée d'Orsay, Paris

6. Vincent van Gogh
Rain, 1889
Oil on canvas, 73.5 x 92.5 cm
Philadelphia Museum of Art,
Philadelphia
The Henry P. McIlhenny
Collection, in memory
of Frances P. McIlhenny

7. Vincent van Gogh
Wheatfield with Crows, 1890
Oil on canvas, 50.5 x 103 cm
Van Gogh Museum,
Amsterdam

8. Paul Gauguin
*Self-Portrait with Yellow
Christ*, 1890-1891
Oil on canvas, 38 x 46 cm
Musée d'Orsay, Paris

9. Paul Gauguin
Self-Portrait with Palette,
1891
Oil on canvas, 55 x 46 cm
Private collection, New York

10. Paul Gauguin
*Aha oe feii? (What! Are you
jealous?)*, 1892
Oil on canvas, 68 x 92 cm
Pushkin Museum, Moscow

11. Paul Gauguin
Still-Life with Fan,
circa 1888-1889
Oil on canvas, 50 x 61 cm
Musée d'Orsay, Paris

12. Émile Bernard
Marché à Pont-Aven
(*Market in Pont-Aven*), 1888
Oil on canvas, 65.5 x 91 cm
The Museum of Fine Arts,
Gifu

13. Émile Bernard
Breton women picking apples,
1889
Oil on canvas, 86.3 x 55 cm
Private collection

14. Paul Cézanne
Mount Sainte Victoire, 1905
Oil on canvas, 63.5 x 83 cm
Kunsthaus, Zurich

15. Paul Cézanne
Mount Sainte Victoire, 1905
Oil on canvas, 60 x 72 cm
Kunstmuseum, Basel

16. Henri Matisse
Luxe, Calme et Volupté,
1904-05
Oil on canvas, 98 x 118 cm
Musée national d'Art moderne
– Centre Georges Pompidou,
Paris
In storage at the Musée
d'Orsay

**17. Henri
de Toulouse-Lautrec**
La toilette, 1889
Oil on cardboard, 67 x 54 cm
Musée d'Orsay, Paris

**18. Henri
de Toulouse-Lautrec**
The Bed, circa 1892
Oil on cardboard,
54 x 70.5 cm
Musée d'Orsay, Paris

**19. Henri
de Toulouse-Lautrec**
*The Red-Haired Girl
in a White Blouse*, 1889
Oil on canvas, 59.5 x 48.2 cm
Museo Thyssen-Bornemisza,
Madrid

**20. Henri
de Toulouse-Lautrec**
Woman at the Window, 1893
Oil on cardboard, 57 x 47 cm
Musée Toulouse-Lautrec, Albi

21. Pierre Bonnard
Siesta – The Artist's Studio,
1900
Oil on canvas, 109 x 132 cm
National Gallery of Victoria,
Melbourne

22. Pierre Bonnard
Nude in the tub, 1903
Oil on wood, 44 x 50 cm
Fondation Bemberg, Toulouse

23. Édouard Vuillard
*Misia and Félix Vallotton
at Villeneuve*, 1899
Private collection

24. Édouard Vuillard
La Soupe d'Annette, 1900
Oil on cardboard on wood
35.2 x 61.8 cm
Musée de Saint-Tropez,
L'Annonciade

25. Gustav Klimt
Rosebushes under Trees,
circa 1905
Oil on canvas, 110 x 110 cm
Musée d'Orsay, Paris

26. Gustav Klimt
*Avenue in Schloss Kammer
Park*, 1912
Oil on canvas, 110 x 110 cm
Österreichische Galerie
Belvedere, Schloss Belvedere,
Vienna

27. Giovanni Segantini
Highnoon in the Alps, 1892
Oil on canvas, 85.5 x 79.5 cm
Ohara Museum of Art,
Okayama, Kurashiki

28. Giovanni Segantini
Vanity (The source of evil),
1897
Oil on canvas, 77 x 124 cm
Kunsthaus, Zurich

29. Giacomo Balla
*Open-air portrait
(Leonilde Imperatori)*,
circa 1902-03
Oil on canvas,
154.5 x 113 cm
Galleria Nazionale d'Arte
Moderna, Rome

30. Giacomo Balla
La pazza (The Madwoman),
1905
Oil on canvas, 175 x 115 cm
Galleria Nazionale d'Arte
Moderna, Rome

31. Félix Vallotton
*The Balloon (Corner of a Park
with a Child Playing)*, 1899
Oil on canvas, 61 x 48 cm
Musée d'Orsay, Paris

32. Giacomo Balla
The Fiancee in the Pincio,
1902
Oil on canvas, 60.5 x 90 cm
Galleria Nazionale d'Arte
Moderna, Rome
Grassi Collection

**33. Henri Rousseau
("Le Douanier")**
The Sleeping Gypsy, 1897
Oil on canvas,
129.5 x 200.7 cm
The Museum of Modern Art,
New York
Gift of Mrs. Simon
Guggenheim

**34. Henri Rousseau
(Le Douanier)**
The Snake Charmer, 1907
Oil on canvas,
169 x 189.5 cm
Musée d'Orsay, Paris

35. Odilon Redon
Le Rêve (*The Dream*),
circa 1904
Oil on canvas, 56 x 43 cm
Private collection

36. Odilon Redon
Le Mystère (*The Mystery*),
circa 1910
Oil on canvas, 73 x 54.3 cm
Phillips Collection, Paris

37. Gustave Moreau
The Griffon's Fairy,
circa 1880
Oil on canvas, 124 x 94 cm
Musée Gustave Moreau, Paris

38. Gustave Moreau
Venice, *circa* 1880
Watercolour, 25.5 x 23.5 cm
Musée Gustave Moreau, Paris

39. Pierre Bonnard
Poster for La Revue blanche,
1894
Musée national d'Art moderne
– Centre Georges Pompidou,
Paris

**40. Henri
de Toulouse-Lautrec**
Aristide Bruant, 1892
Lithography, 141 x 98 cm
Musée Toulouse-Lautrec, Albi

41. Giovanni Boldini
Mademoiselle Laure, 1910
Oil on canvas, 46 x 66 cm
Private collection

42. Giovanni Boldini
The Young Subercaseaux,
1891
Oil on canvas, 170 x 98.5 cm
Museo Giovanni Boldini,
Ferrara

43. Gustav Klimt
The Kiss, 1907-1908
Oil on canvas, 180 x 180 cm
Österreichische Galerie
Belvedere, Schloss Belvedere,
Vienna

44. Gustav Klimt
Portrait of Emilie Flöge, 1902
Oil on canvas, 181 x 84 cm
Historisches Museum
der Stadt Wien, Vienna

**45. Joaquín Sorolla
y Bastida**
Walk on the Beach, 1909
Oil on canvas, 205 x 200 cm
Museo Sorolla, Madrid

**46. Joaquín Sorolla
y Bastida**
The Young Yachtsman, 1909
Museo Sorolla, Madrid

47. Amedeo Modigliani
Red Nude, 1917
Oil on canvas, 60 x 92 cm
Private collection

48. Amedeo Modigliani
Portrait of Moïse Kisling,
1915
Oil on canvas, 37 x 29 cm
Pinacoteca di Brera, Milan
Jesi Collection

49. Amedeo Modigliani
Paul Guillaume Seated, 1916
Oil on canvas, 81 x 54 cm
Civiche Raccolte d'Arte, Milan

50. Edward Steichen
Maurice Maeterlinck, 1906
Black and white photography,
214 x 162 cm
Musée d'Orsay, Paris

51. Edward Steichen
Eleonora Duse, 1903
Black and white photography,
215 x 163 cm
Musée d'Orsay, Paris

Events in the Arts	Historical events

1870

The French are defeated in the Battle of Sedan and Napoleon III is captured. The French Third Republic is proclaimed.

1874

The first Impressionist exhibition is held at the studio of the photographer Nadar. Monet: *Impression, soleil levant*.

1878

Cézanne is rejected by the Paris Salon.

1882

Redon publishes his series of lithographs *À Edgar Allan Poe*.
Puvis de Chavannes paints *Deux pays*.
Cézanne adopts Mount Sainte Victoire as his favourite subject.

1883

First encounter between Seurat and Puvis de Chavannes. The Galleria d'Arte Moderna is established in Rome.

Karl Marx dies.

1884

Seurat presents *Bathers at Asnières* at the Salon des Indépendants, and begins work on *A Sunday on La Grande Jatte*.
The Société des Artistes Indépendants is founded in Paris. Les XX is founded in Brussels. The first Salon des Artistes Indépendants is held.

Trade unions gain legal status in France and divorce is legalised.
Huysmans publishes *À rebours*.

1886

Jean Moréas publishes the "Symbolist Manifesto" in *Le Figaro*. Félix Fénéon, who coined the term "Pointillisme", adopts the term "Neo-Impressionism".

The rise of the nationalistic Boulangisme movement in France, named after the Minister of War, Georges Ernest Boulanger.

1887

Seurat goes back to work on *Sunday on La Grande Jatte*. Gauguin leaves France for Martinique.
Muybridge publishes *Animal Locomotion*, stop-action photographs of movement, in New York.

The tripartite alliance formed in May 1882 between Germany, Austria-Hungary and Italy to ensure stability in the Mediterranean region is renewed.

90

	Events in the Arts	Historical events
1888	Seurat meets Theo van Gogh. Gauguin and Vincent van Gogh work together in Arles for two months.	Italy and France clash over customs duties. The Convention of Constantinople guarantees the right of passage to all ships in the Suez Canal. The first Kodak camera is introduced.
1889	The Eiffel Tower is inaugurated. Gabriele d'Annunzio publishes *Il piacere*. Giovanni Verga publishes *Mastro don Gesualdo*.	Failed coup d'état by Boulanger in France. The Second Socialist International is founded in Paris. The first of May becomes a day dedicated to workers.
1890	Vincent van Gogh commits suicide. Les Nabis form in Pont-Aven.	Boulanger commits suicide in Brussels. The first steel-framed skyscraper is built in Chicago.
1891	Segantini, Morbelli and Previati present themselves at the first Brera Triennale in Milan as a group: Divisionism is recognised as a current in painting. Aurier provides a definition for Symbolism in *Mercure de France*. Gauguin embarks for Tahiti. Toulouse-Lautrec's Moulin Rouge Manifesto. Georges Seurat dies.	On May first in Paris the army fires at protesting miners, while Turati inaugurates the Party of Italian Workers in Genoa. Pope Leo XIII issues the Encyclical *Rerum Novarum*.
1895	Vollard puts on a major Cézanne exhibition. Rodin unveils his *Burghers of Calais*.	The art merchant Bing founds Art Nouveau – La Maison Bing. Invention of cinema.
1897		The Viennese Secession was formed by a group of Austrian artist breaking away from the Wiener Künstlerhaus.
1898		The Berlin Secession.
1899	Signac writes *D'Eugène Delacroix au Néo-Impressionnisme*, summing up the principles of Divisionism.	
1907	Picasso exhibits his *Les Demoiselles d'Avignon*.	
1910		Roger Fry coins the term Post-Impressionism.

Biographies
of the main Artists

Paul Gauguin

(Paris, 1848 – Atuana Hiva-Oa, 1903)
Paul Gauguin was born into an antimonarchist family in Paris in 1848. He spent his early years in Peru. After returning to France, from 1865 to 1867 he worked as a pilot's assistant in the merchant marine. In 1870 he was involved in the Franco-Prussian conflict. The following year he was hired by a money-changing agency in Paris, and he began to develop his interest in painting and came into contact with a number of French artists. A friend of Pissarro, Cézanne and Degas, he exhibited on many occasions with the Impressionists. From 1886 to 1890 he lived in Brittany, where he was part of the Pont-Aven school and with Bernard helped developed the Cloisonnism style, characterised by flat fields of colour with thick borders showing a kinship to primitive and Japanese art. In 1888, he was Van Gogh's guest in Arles. After a strong disagreement with the Dutch painter, Gaugin returned to Paris, where he got involved in the Symbolist movement and developed close relations with Odilon Redon and Stéphane Mallarmé. Toward the end of the century, financial troubles drove him away from Paris once again. He went to Rouen, Copenhagen, Panama and Martinique, landing in Tahiti in 1891 on an official mission of the Ministry of Public Education and Fine Arts. In 1893 he returned to France for two years before moving definitively to Polynesia, settling on Tahiti and then in the Marquesas islands. The figurative tradition here would be a determining influence in his final phase.

Gustav Klimt

(Vienna, 1862 – Neubau, 1918)
Gustav Klimt was born in Baumgarten, which at the time was an independent town near Vienna. In 1876 he enrolled in the Vienna School of Arts and Crafts. Three years later, with his brother, Ernst, and Franz Matsch, he was commissioned to decorate the courtyard of the Kunsthistorisches Museum, following the project of Laufberger, Klimt's professor. From 1886 to 1888 he worked on the decoration of the Burgtheater, executing a series of panels dedicated to various historic and modern theatres. In 1897, after emerging from a deep crisis following the deaths of his father and brother, Klimt became founding member and president of the Vienna Secession.

The group's first exhibition was held in 1898 in the building specially designed by Joseph Maria Olbrich, with Klimt's works displayed alongside those of Puvis de Chavannes, Auguste Rodin, Fernand Khnopff, Arnold Böcklin and Alfons Mucha. Later that year, Klimt began working closely with the magazine of the Vienna Secession, *Ver Sacrum*.

In 1894, the University of Vienna commissioned him to create three paintings to decorate the ceiling of the Great Hall. The paintings were not be completed until the turn of the century and became an object of strident criticism for their excessive sensuality. In the end, Klimt withdrew from the contract. He was already a member of the Berlin and Munich Secessions when he won the gold medal at the 1900 Paris World's Fair for his *Philosophy*. In the early years of the twentieth century he visited Ravenna, where he was able to view the splendid Byzantine mosaics. These works would have a strong stylistic influence in the further work of the artist, who was also quite fascinated by the goldsmith work of his father and brother. After the break-up of the Secession, he aligned with the Wiener Werkstätte, and worked on the lavish decorations of Palais Stoclet in Brussels. In 1910 he was invited to the Venice Biennale, and the following year he won the first prize at the Rome International Art Exhibition with

Death and Life. In 1918 he suffered a stroke and was painted on his deathbed by his friend Egon Schiele.

Amedeo Modigliani
(Livorno, 1884 – Paris, 1920)

Modigliani was born in 1884 in Livorno into a family in severe financial difficulty. While his mother was giving birth, the bailiffs were in their house to repossess their belongings. Modigliani's father and grandfather saved many of the family treasures by piling them on the bed where Modigliani's mother was; the law forbade the seizure of the bed of a pregnant woman or a mother with a newborn child.

Amedeo was a frail child, suffering repeated bouts of pleurisy. Early on developed a passion for drawing; he was quite young when he began working at the studio of Guglielmo Micheli, one of the most important art studios in the city. It was there, in 1898, that he met Giovanni Fattori. In 1902, he enrolled in the Free School of Nude Studies of Florence, and the following year, in the Venice Fine Arts Academy, where he discovered a deep passion for hashish, which distracted him from his studies and drew him toward the city's outskirts. In 1906, he moved to Paris, taking up residence in the Bateau-Lavoir in Montmartre, and began to be influenced by such great French masters as Toulouse-Lautrec and Cézanne and to develop his own rapid personal style.

In 1909, he returned to Tuscany, wasted away by his precarious health and debauched lifestyle. When he returned to Paris, he opened a studio in Montparnasse and concentrated mainly on sculpture, inspired partially by his acquaintance with Brancusi, whom he had met through the art merchant Guillaume. A number of works from this period were exhibited at the Salon d'Automne in 1912. Modigliani's attacks of pleurisy now transformed into tuberculosis, and the dust generated from his sculptural work only made matters worse. He returned

to painting, creating some of the period's most famous portraits.

Modigliani became famous for his drunken displays in public; the French nicknamed him "Modi" in a play on the French *maudit*, "accursed". His addiction to alcohol and other drugs only worsened after his failed attempt to enlist in the army during the First World War; he was rejected due to his frail health. In 1917 he held his first solo exhibition at the Berthe Weill Gallery. However, it was closed by the police only a few hours after it opened due to the presence of numerous nudes.

The artist married Jeanne Hébuterne the following year in Nice. Their daughter would be born in the same city. He returned later to Paris, suffering from tubercular meningitis. One day, Kisling and Ortis de Zarate found Modigliani in his bed, in an alcoholic delirium and clinging to Jeanne, who was nearly nine months pregnant. Modigliani soon died, and two days later, the inconsolable Jeanne threw herself from the fifth-story window of her parents' home, killing herself and the couple's unborn child.

Georges Seurat
(Paris, 1859 – Gravelines, 1891)

Seurat was born in Paris in 1859 into a middleclass family. He enrolled in the Paris School of Fine Arts in 1877, strongly influenced by Ingres, Goya, Rembrandt and Puvis de Chavannes. The only break he took from school was when he had to do his military service. He began his bona fide artistic career in 1882. Two years later he finished *Bathers at Asnières*, the first of his large-format works, and in 1886 *A Sunday on La Grande Jatte*, his most important work. Seurat founded the Société des Artistes Indépandants and led the Post-Impressionist movement together with such notables as Signac and Pissarro.

A withdrawn and solitary man by nature, he broke off all friendships over time. At the eighth Salon des Artistes Indépendants he exhibited *The Circus*, a work he initiated

during a summer stay in Gravelines but never finished. He died quite unexpectedly of a throat infection during the exhibition; he was thirty-one.

Henri de Toulouse-Lautrec
(Albi, 1864 – Malromé, Bordeaux, 1901)
Born 24 November 1864, into a very old noble family. Began drawing as a child, during long spells of inactivity forced on him by poor health, aggravated by two falls which had broken both femurs and stopped his legs developing properly.

In 1872 the family moved to Paris, where his father introduced him to the painter Princeteau, who encouraged him in painting subjects on horseback. In 1882 he went to learn in Bonnat's studio, and the following year benefited greatly from lessons with Ferdinand Cormon. He met the Impressionists and studied their works, in particular those of Degas and Van Gogh, though he never exhibited in their shows.

He became a habitué of Montmartre, the ballet, theatres and café-concerts which became the backdrop to his most famous paintings. He worked with many newspaper and reviews as a cartoonist, experimenting with new engraving techniques and designing some thirty posters which caused a great stir with their stylistic novelty, derived in part from his interest in Japanese prints. He made a series of about forty paintings devoted to Paris brothels; the ensuing scandal helped to build his legend as a wicked artist and outlaw. He died on 9 September 1901, at the age of just 37.

Vincent van Gogh
(Groot Zundert, 1853 – Auvers-sur-Oise, 1890)
Eldest son of a Protestant pastor; after completing school he worked for a firm of art dealers first at the Hague and then, from 1873, in London. In 1875 he was moved to the Paris office, but was sacked the following year and returned to the Netherlands. After trying one thing and another, he moved to Mons in 1878, where he preached to the miners; but he took their side during strikes, and was sacked by the local religious authorities. He began to draw, and after deciding to devote himself to painting left for Brussels. He next moved to Nuenen, where he painted masterpieces such as the *The Potato Eaters* in 1885; his father died the same year. In 1886 he joined his brother Theo in Paris, where he discovered Impressionist painting and Japanese art, and met Toulouse-Lautrec and Guillaumin. In 1888 he left for Arles, where he painted *Flowering Orchard*, *Night Café*, *The Bedroom*, and other pictures. He shared the "Yellow House" with Gauguin, but after a period of happy mutual stimulation, the two artists quarrelled and Gauguin left: seized with despair, Van Gogh cut off an ear-lobe; he was taken into care and transferred to the Saint-Rémy asylum, where he painted works including *Cypresses* and *Starry Night*. He then left for Auvers-sur-Oise, encouraged and supported by his brother and Dr. Gachet. In 1890 he painted *Cornfield with Crows*. On 27 July that year he shot himself with a pistol, and died two days later.

Selected Bibliography

P. Seghers, *The Art of Painting from the Baroque through Post-Impressionism*, New York-London 1964

J. Rewald, *Post-Impressionism: from Van Gogh to Gauguin*, London 1978

R.R. Brettel, *Post-Impressionists*, Chicago 1987

Courtauld Institute Gallery, *Impressionist and Post-Impressionist masterpieces: the Courtauld Collection*, New Haven-London 1987

A. Kruszynski, *Amedeo Modigliani, portraits and nudes*, Munich–New York 1996

T. Parsons, I. Gale, *Post-Impressionism: the rise of modern art, 1880-1920*, Toronto 1999

C. Wiggins, *Post-Impressionism*, London 1993

J. Ittmann, *Post-Impressionist prints: Paris in the 1890's*, Philadelphia 1998

B. Thomson, *Post-Impressionism*, London 1998

D. Franck, *Bohemian Paris: Picasso, Modigliani, Matisse, and the Birth of Modern Art*, London 2001

A. Salomon, G. Cogeval, *Vuillard. Catalogue critique des peintures et pastels*, Milan 2003

P. Cutler, *Post-Impressionism: a clear insight into artists and their art*, Edinburgh 2004

D. Lewer (edited by), *Post-Impressionism to World War II*, Malden, Oxford 2006